WONDER WOMAN

THE COMPLETE COVERS

VOL. 2

INSIGHT 👁 EDITIONS

San Rafael, California

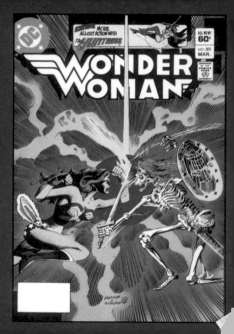

THE MODERN AGE OF AN ICON

Wonder Woman has been ever-present in comics since her debut in 1941 and continues to be one of the most popular characters of all time. This second collection celebrates *Wonder Woman* covers beginning from *Wonder Woman* #301 (Vol. 1, March 1983) and features notable issues by famed comic book artists such as George Pérez, Phil Jimenez, Adam Hughes, and José Luis García-López.

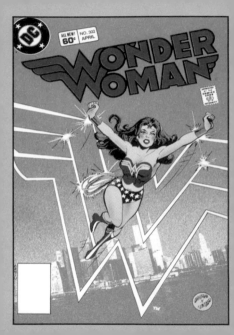

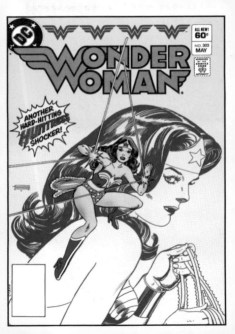

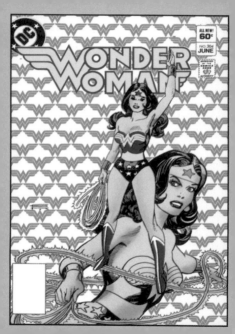

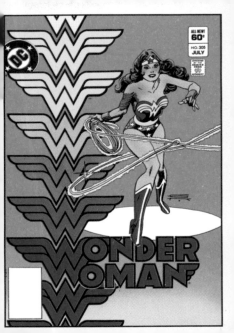

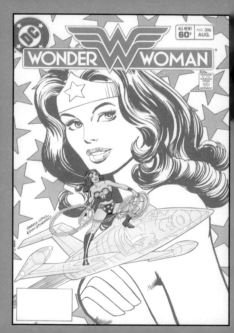

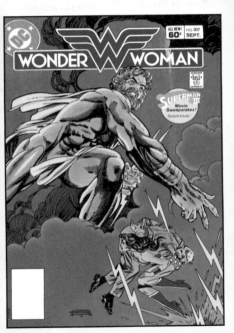

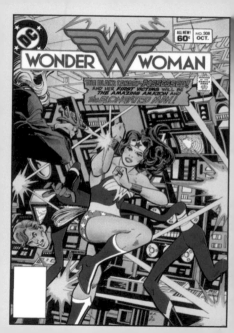

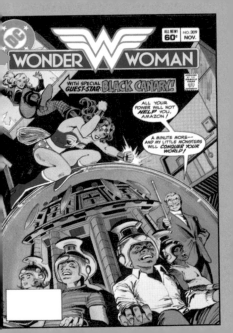

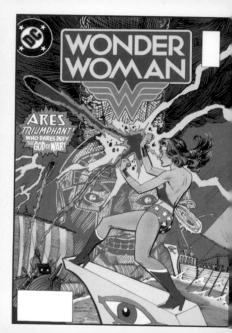

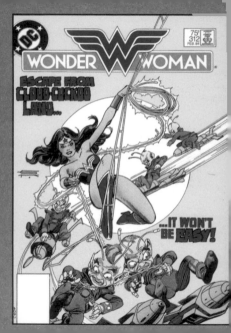

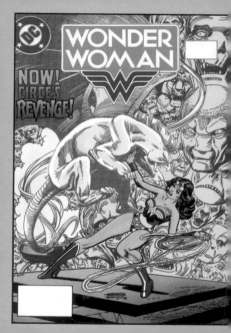

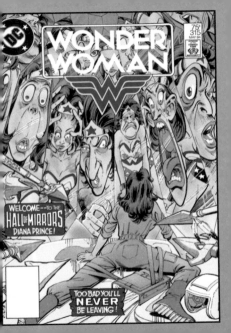

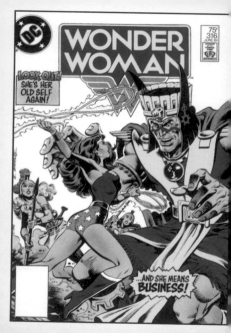

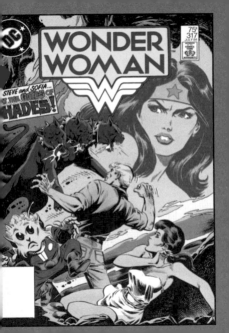

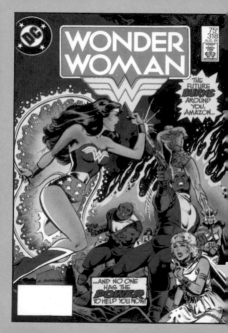

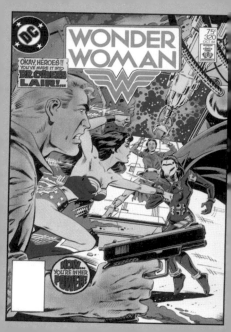

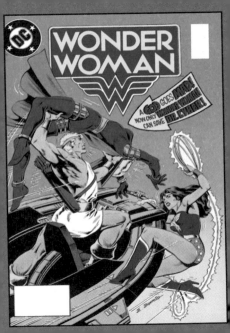

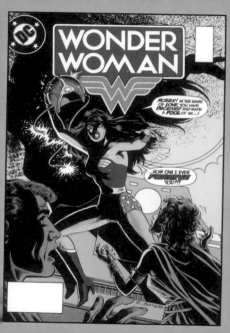

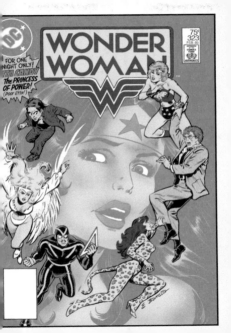

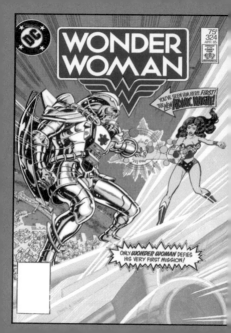

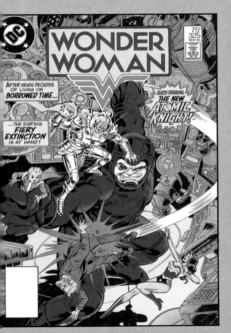

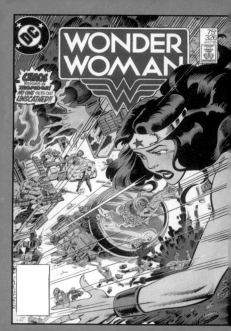

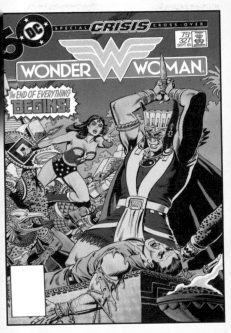

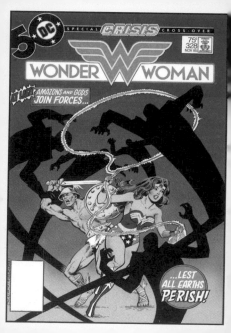

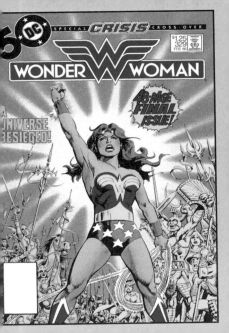

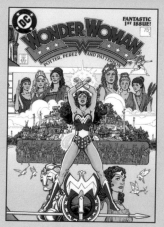

Wonder Woman (Vol. 2) #1

In the first issue of *Wonder Woman (Vol. 2, 1987)* writer George Pérez expanded on Wonder Woman's origin story and emphasized her Amazonian upbringing, in addition to doubling down on the character's association with Greek mythology.

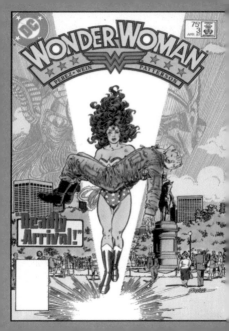

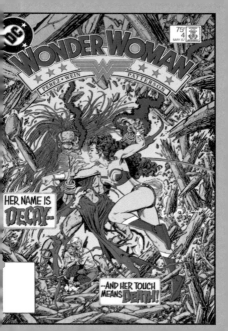

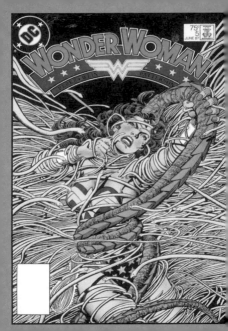

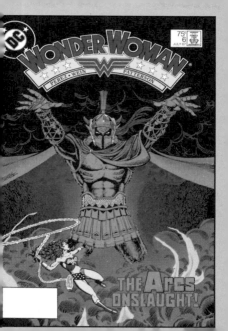

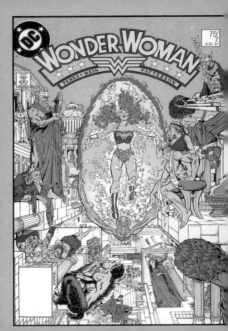

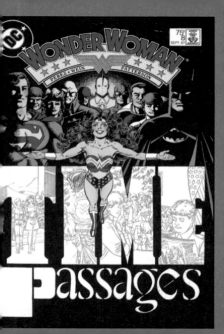

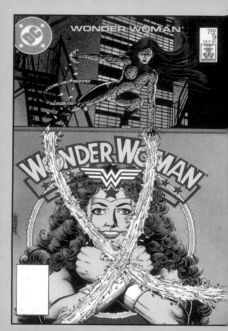

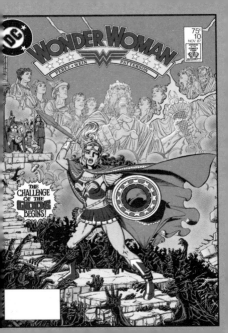

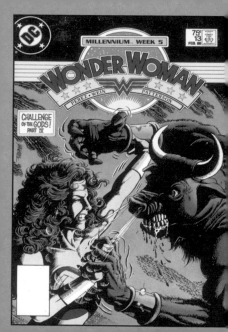

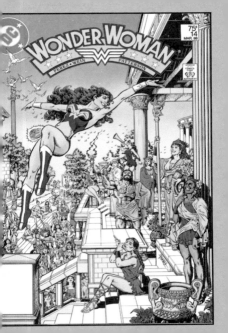

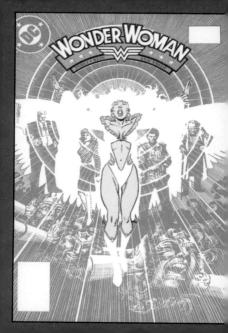

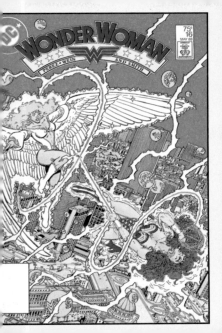

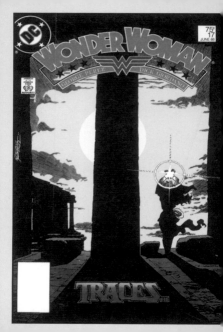

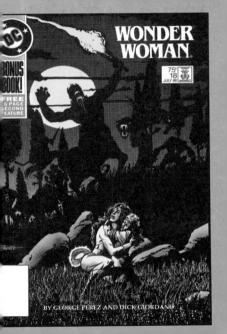

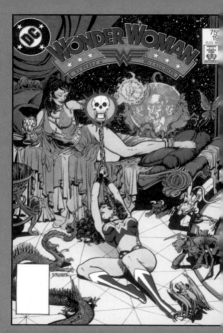

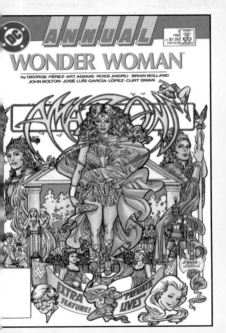

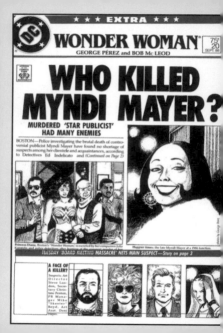

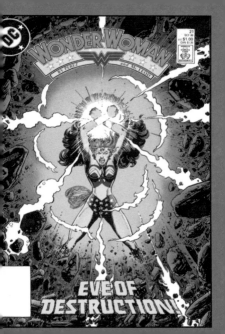

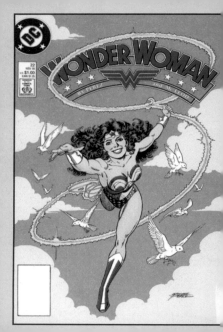

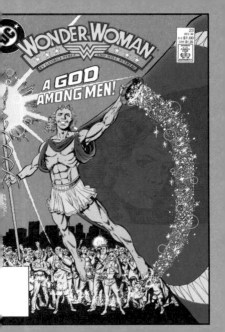

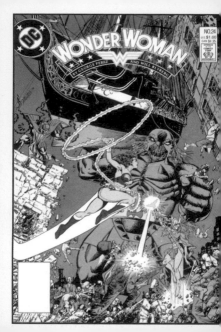

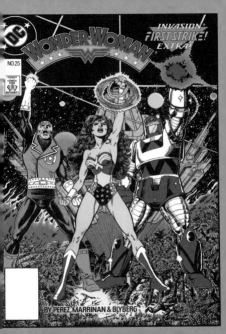

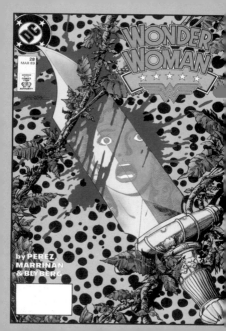

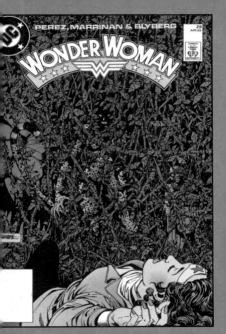

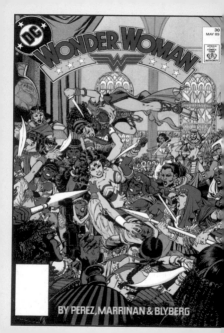

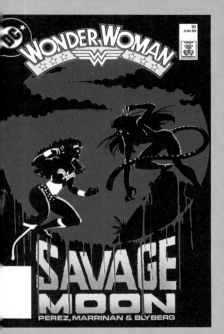

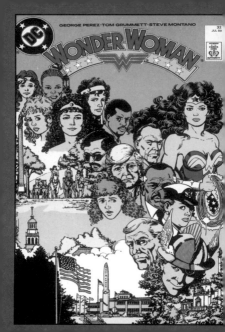

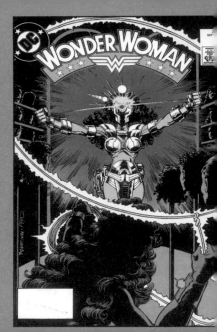

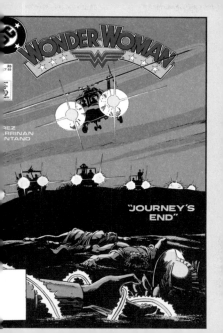

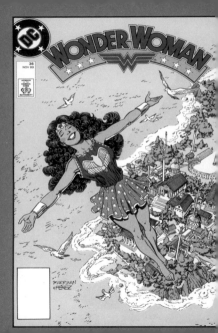

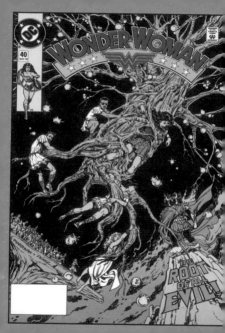

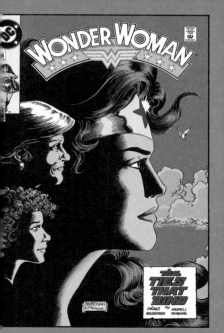

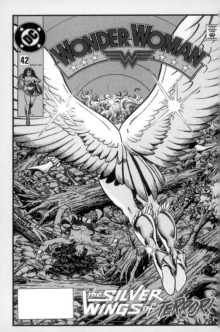

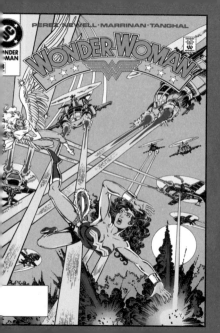

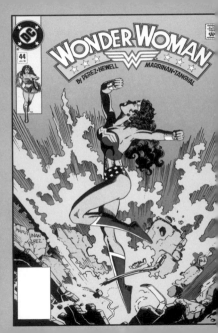

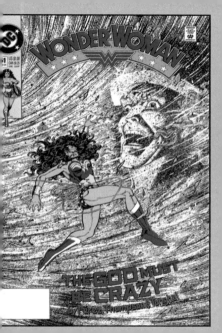

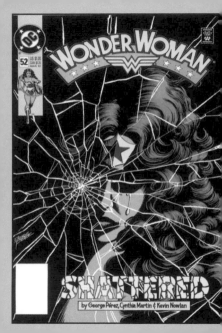

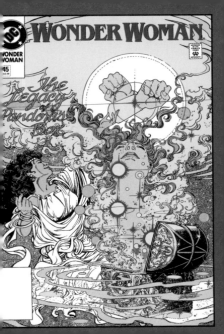

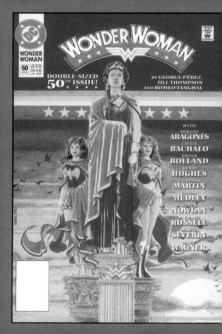

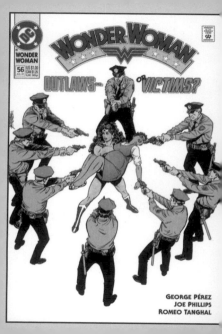

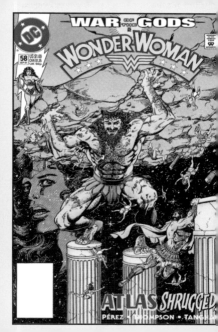

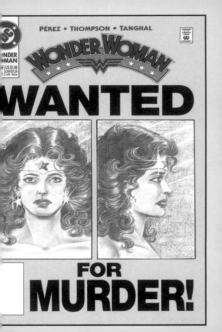

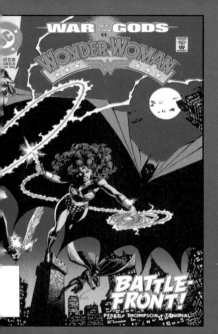

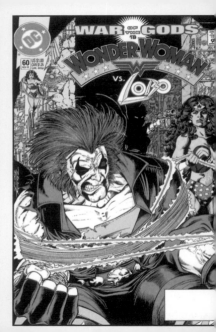

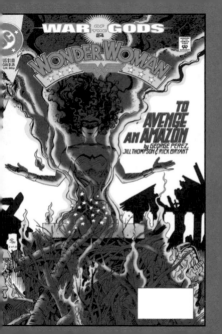

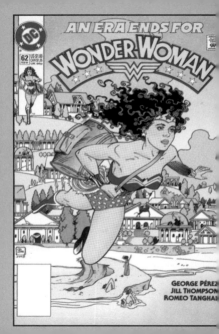

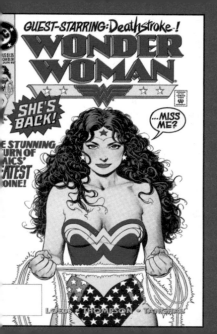

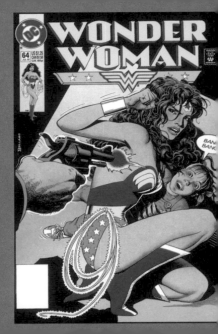

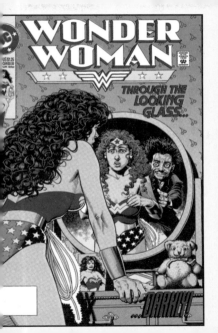

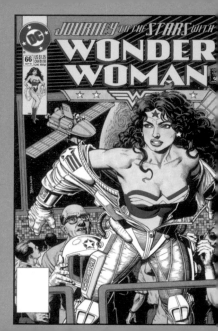

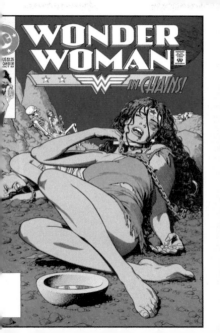

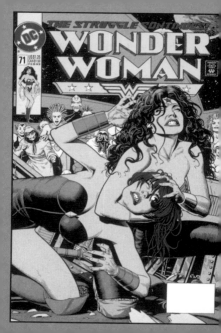

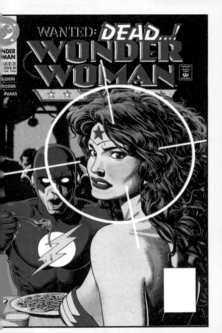

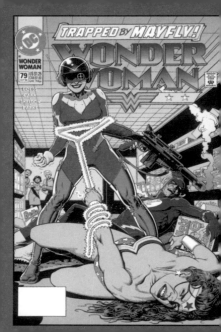

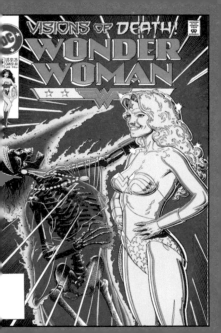

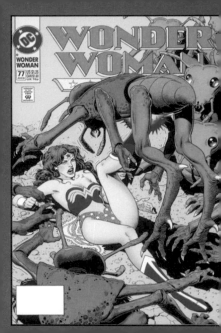

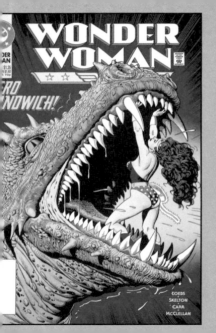

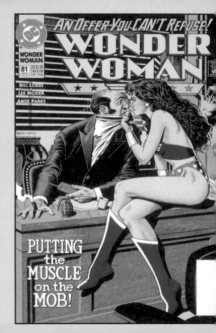

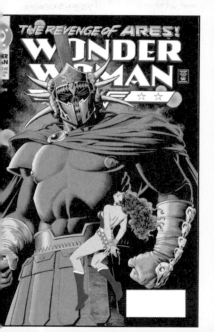

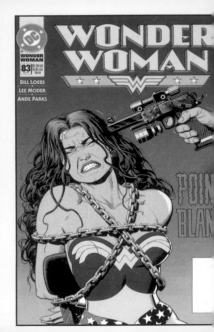

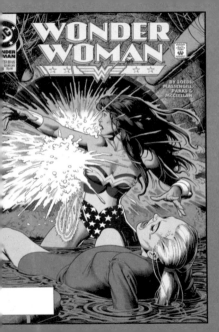

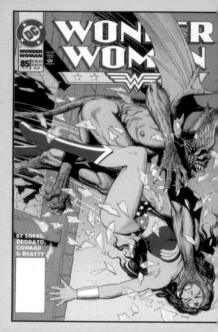

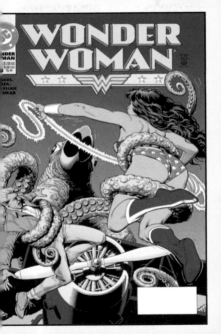

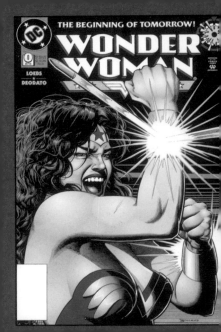

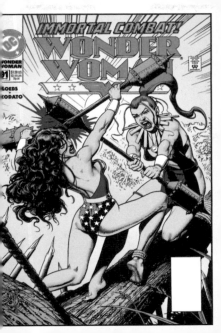

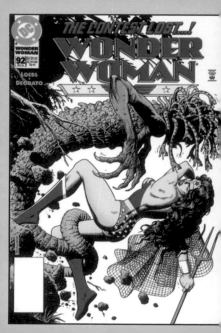

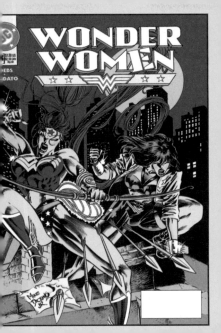

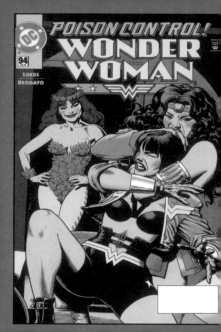

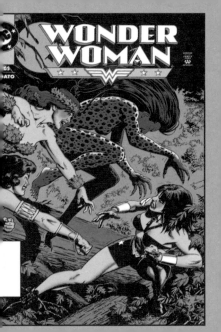

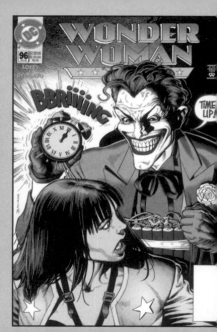

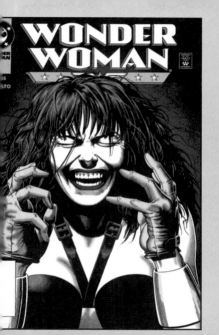

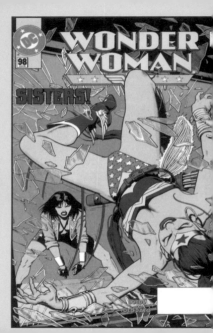

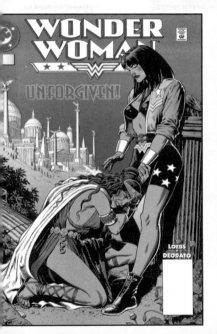

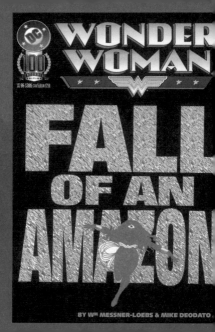

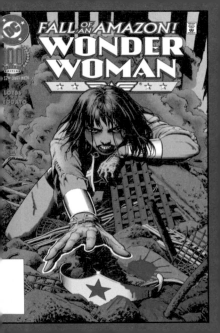

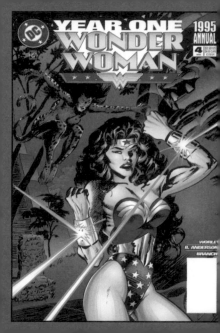

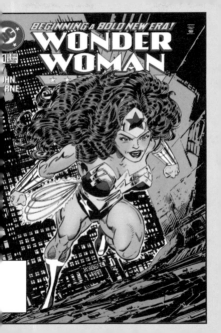

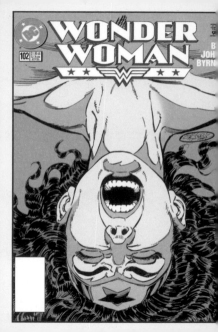

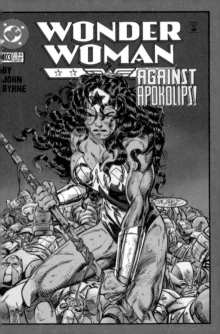

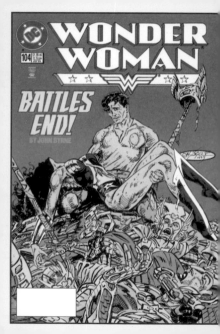

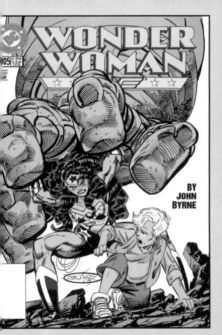

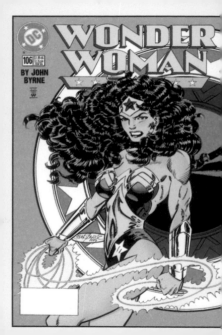

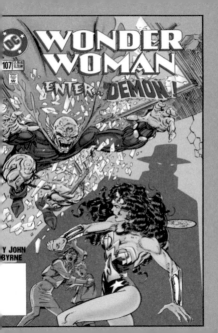

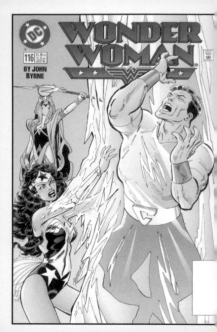

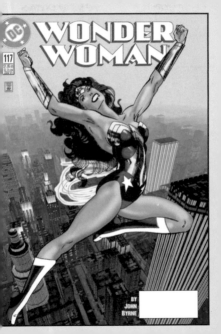

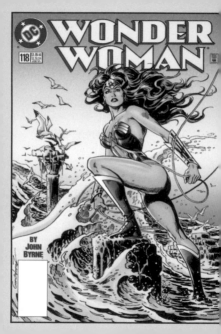

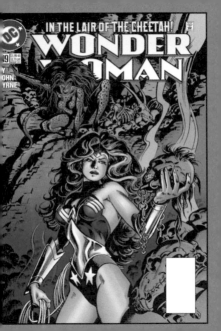

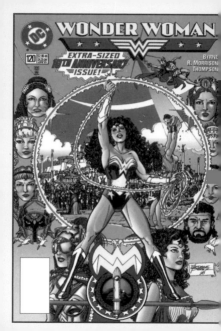

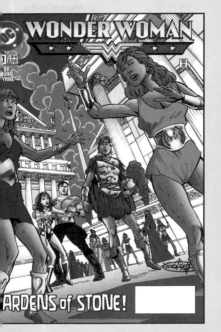

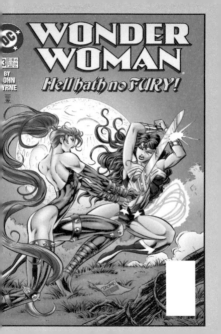

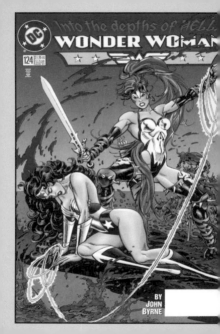

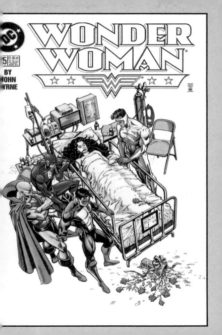

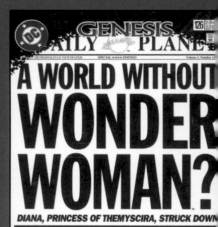

DC GENESIS
126
DAILY PLANET
METROPOLITAN NEWSPAPER · SPECIAL ★★★★ EDITION · Volume I, Number 12

A WORLD WITHOUT WONDER WOMAN?

DIANA, PRINCESS OF THEMYSCIRA, STRUCK DOWN

EXCLUSIVE TO THE PLANET
Story and Pictures by
JOHN BYRNE

(Gateway City) While details are still sketchy, sources in the Gateway City police have confirmed that Princess Diana of Themyscira, the Amazon heroine known as Wonder Woman, was struck down yesterday in a battle with an unknown foe in downtown Gateway.

Wonder Woman was brought to the emergency room of Gateway Memorial Hospital by companions who had, reportedly, taken part in the battle that caused her injuries. According to a doctor at the hospital, Wonder Woman is now suffering from any apparent wounds, but her condition is nonetheless listed as critical.

"Frankly, we're at a loss to explain exact-

ly what her condition is," said Dr. Wing Chin. "From what we've been able to ascertain from her companions, Wonder Woman was the victim of an attack by a... but called Neron who did no physical damage to her per se, but who struck at her very so... This is, needless to say, unknown territory to the medical profession. Pending further tests, all we can do is sustain her physical form and hope for answers."

Members of the JLA are reportedly staying vigil by Wonder Woman's bedside.

(Story continues on 2nd page following)

Princess Diana of Themyscira, in her heroic guise as Wonder Woman.

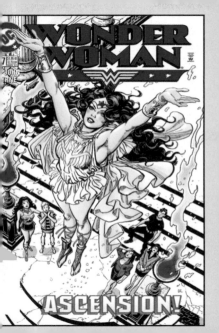

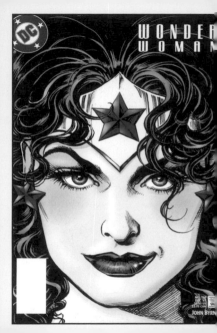

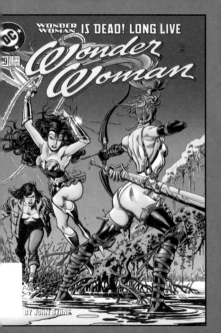

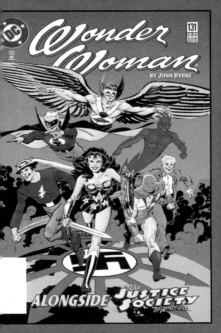

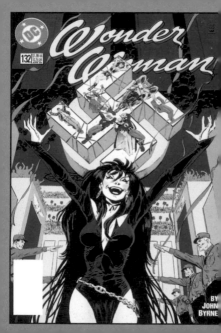

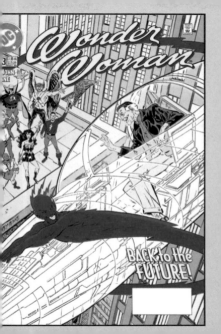

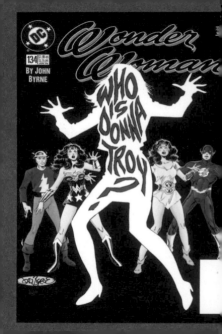

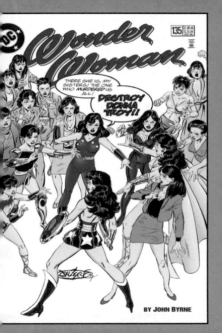

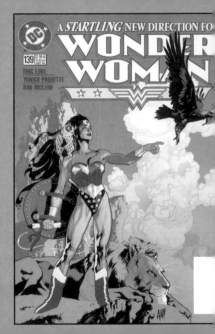

Trade dressed cover requested

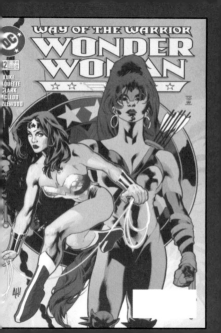

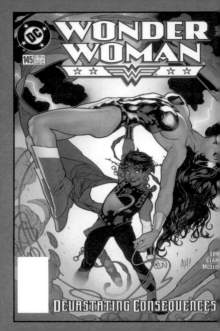

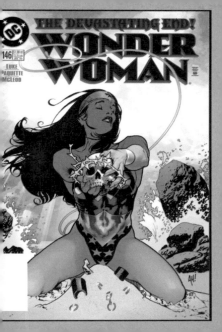

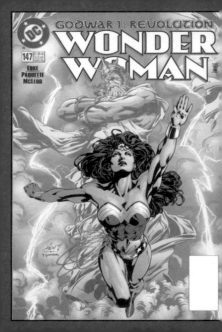

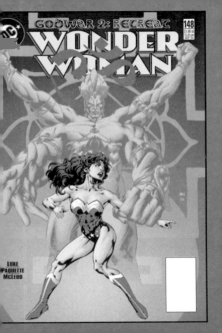

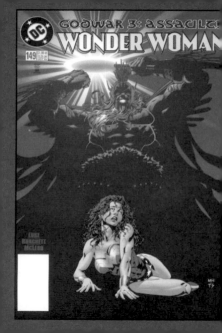

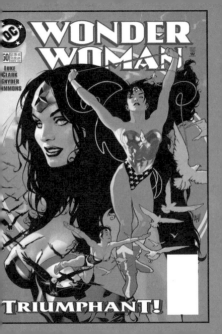

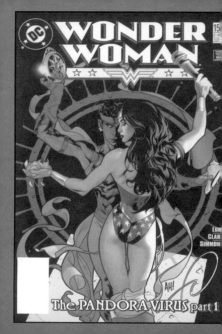

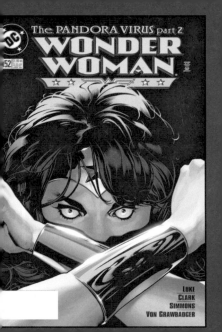

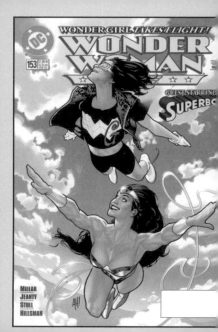

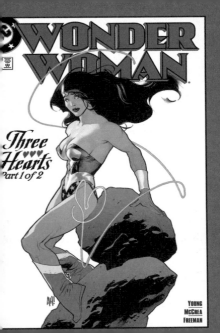

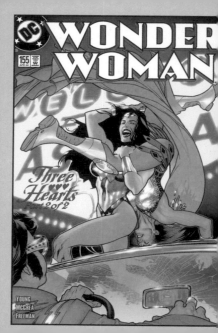

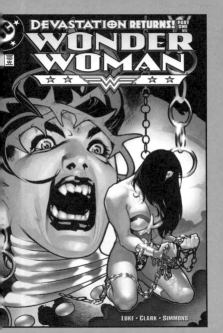

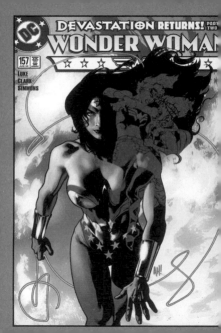

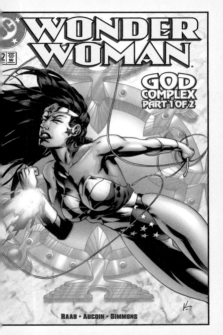

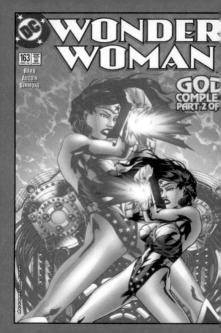

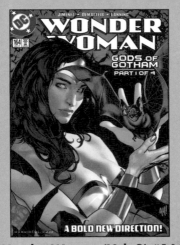

Wonder Woman (Vol. 2) #164

In "Gods of Gotham" (issues #164 to #167),
Wonder Woman travels to Gotham City to
help Batman and his allies. This issue marks
the beginning of writer-artist Phil Jimenez's
Wonder Woman run.

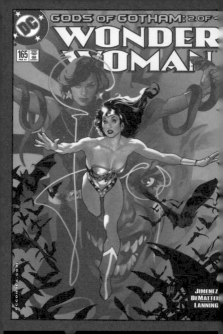

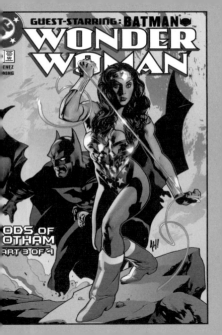

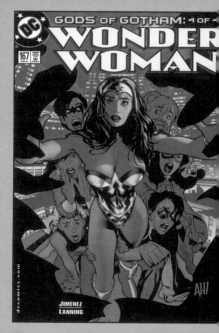

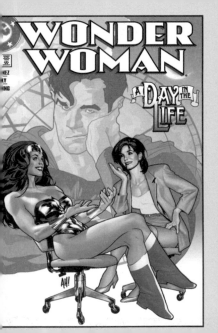

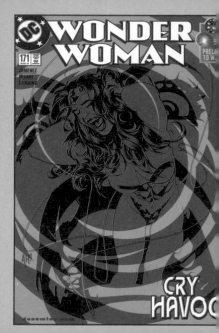

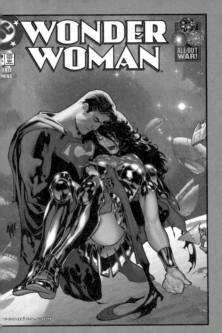

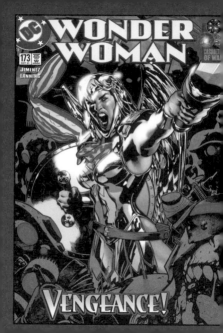

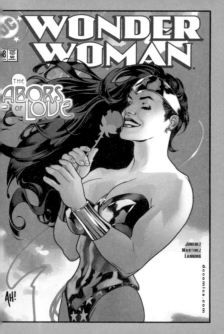

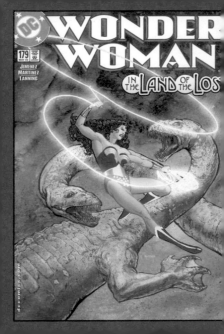

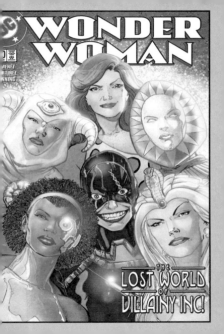

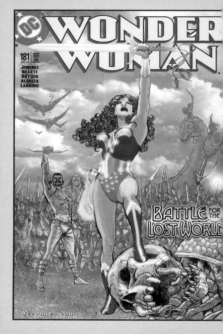

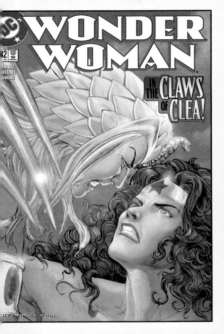

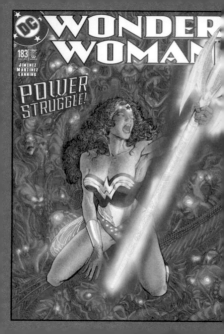

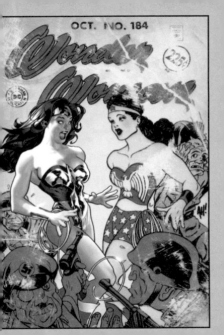

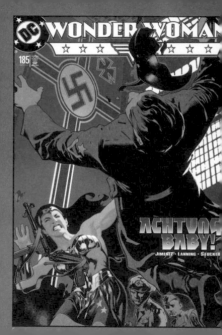

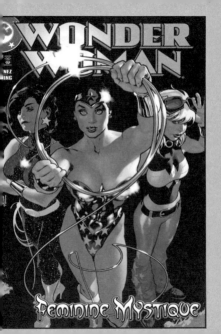

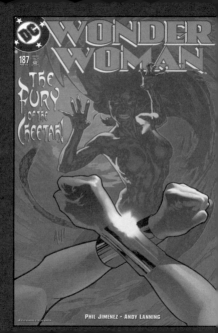

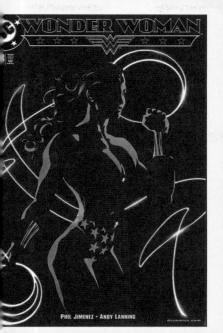

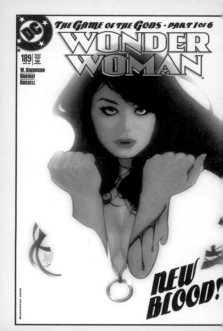

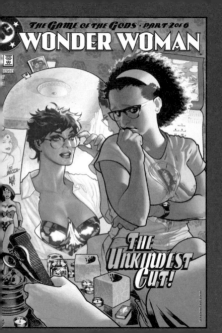

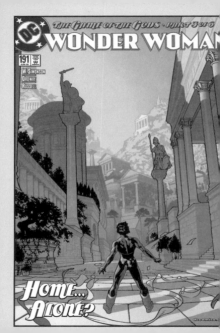

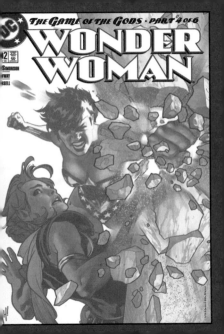

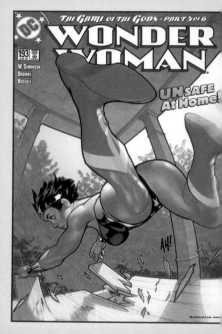

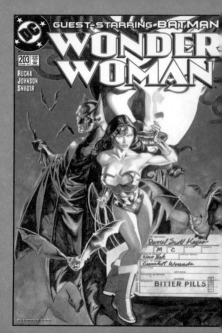

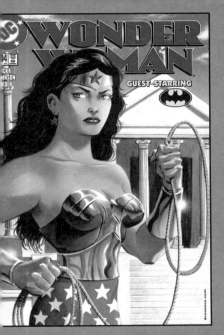

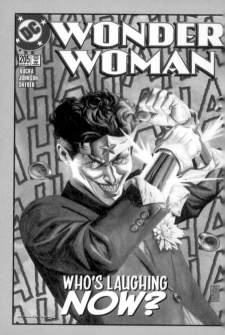

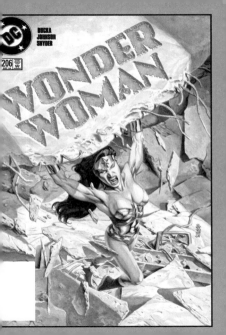

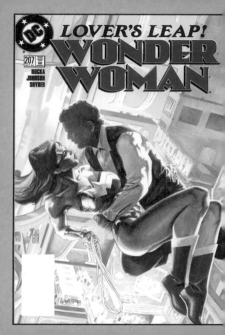

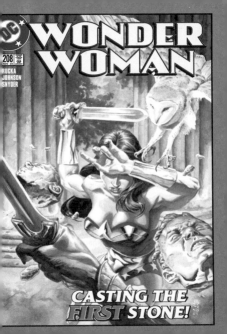

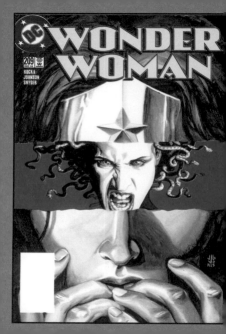

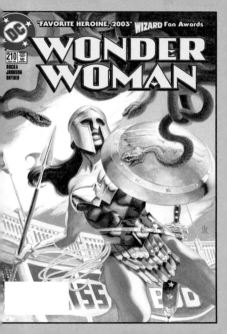

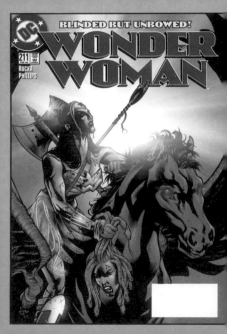

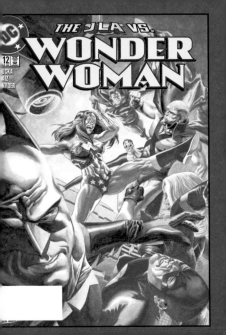

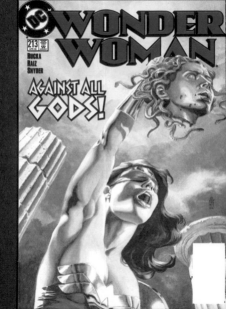

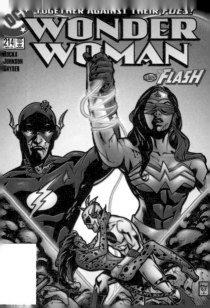

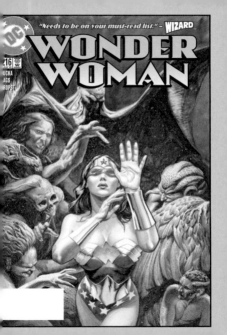

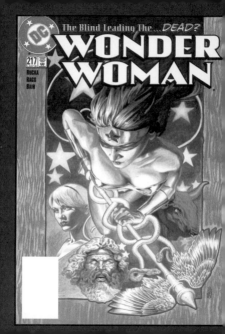

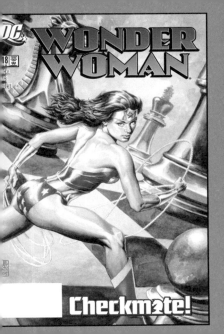

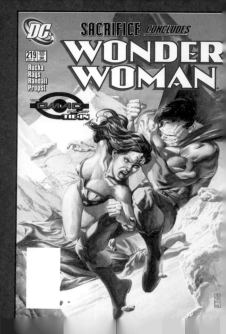

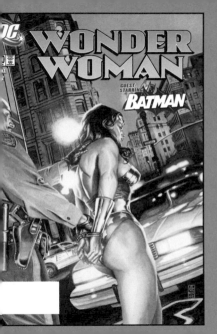

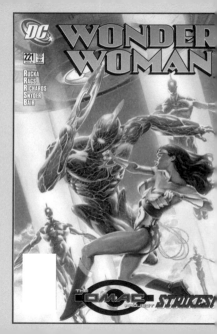

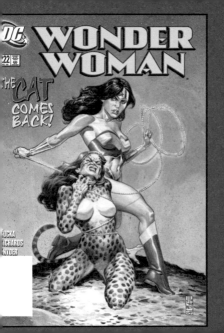

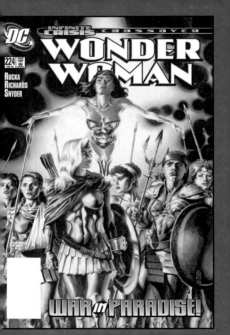

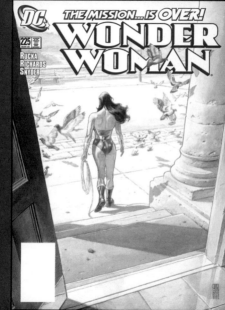

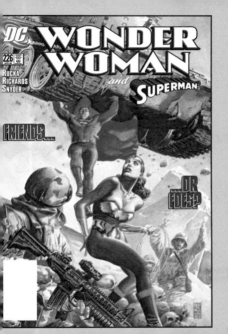

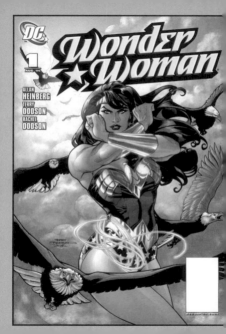

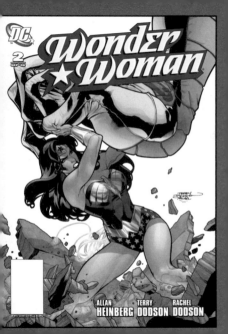

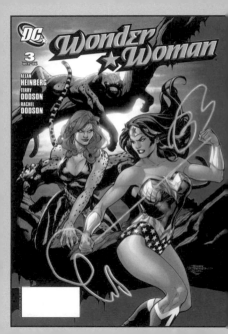

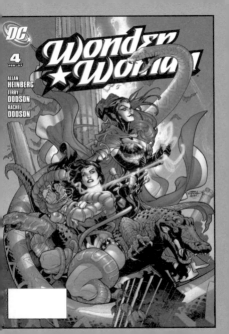

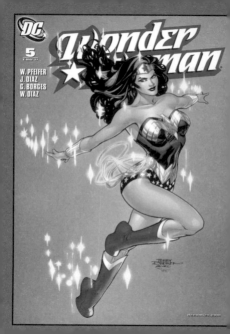

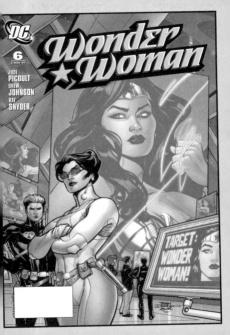

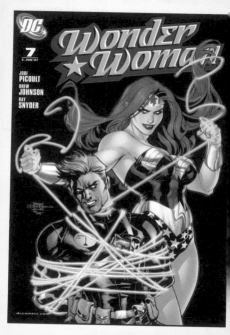

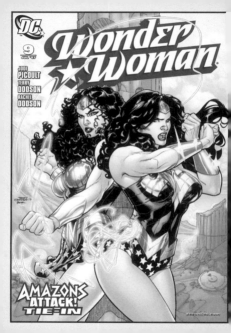

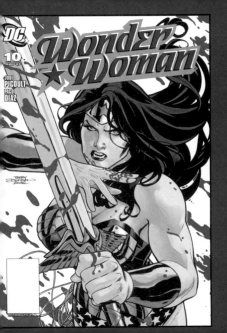

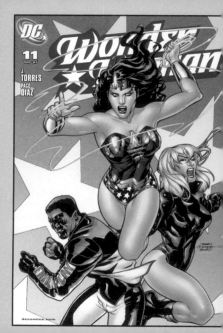

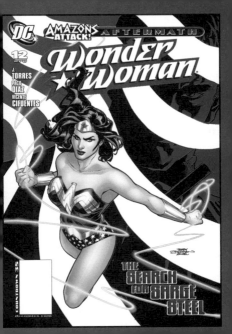

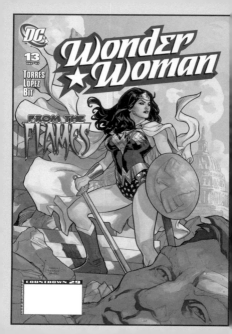

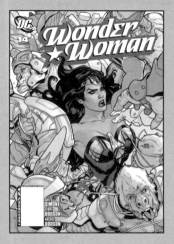

***Wonder Woman* (Vol. 3) #14**
Issue #14 in the third volume of *Wonder Woman* marks the debut of Gail Simone's take on the character. Simone would go on to become the longest-running female writer in *Wonder Woman*'s history.

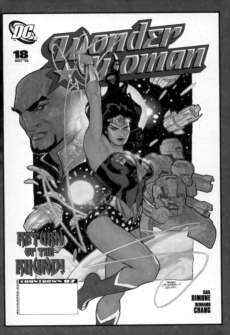

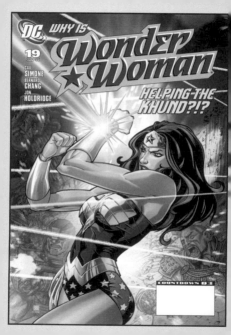

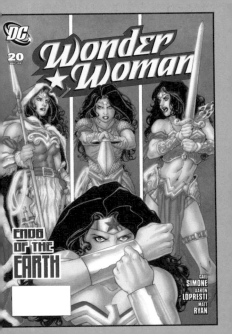

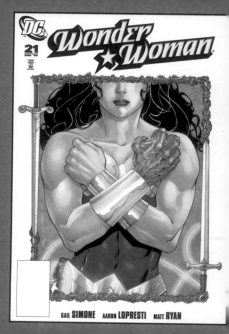

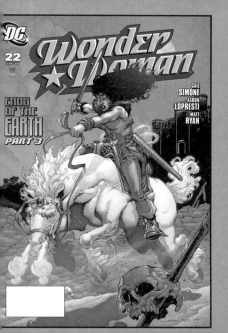

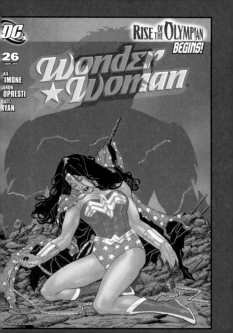

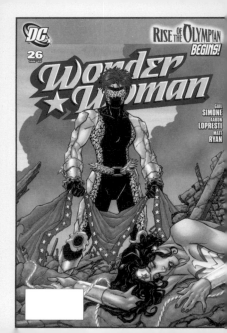

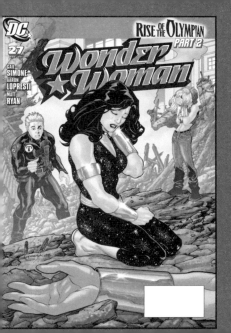

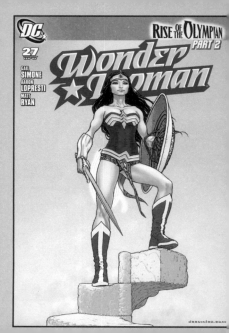

28
MAR '09

Wonder Woman

CHEETAH

GAIL
SIMONE

AARON
LOPRESTI

MATT
RYAN

FACES OF EVIL

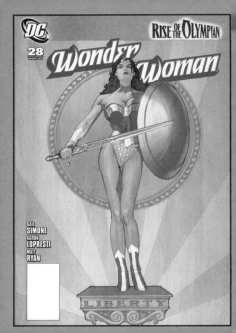

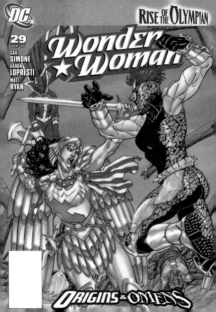

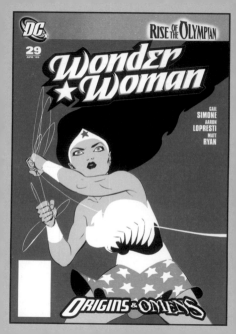

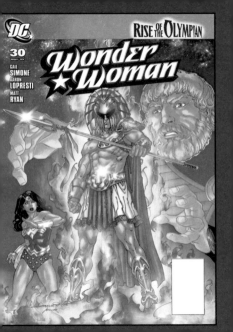

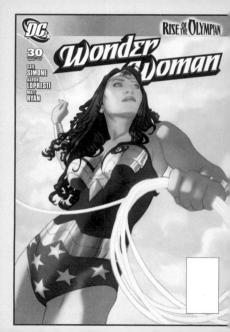

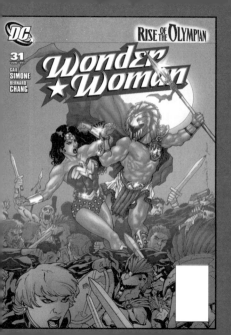

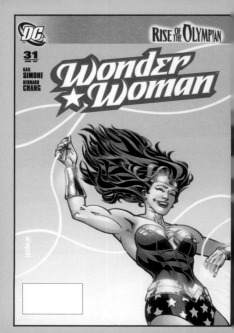

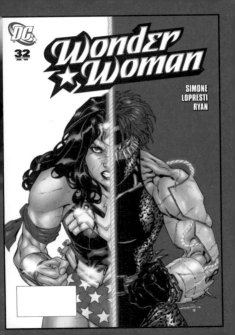

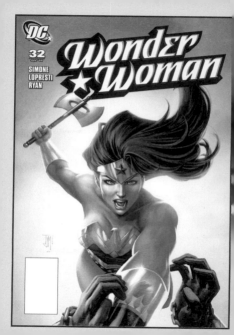

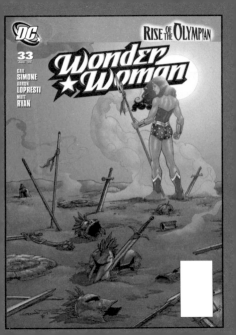

INSIGHT
EDITIONS

PO Box 3088
San Rafael, CA 94912
www.insighteditions.com

f Find us on Facebook: www.facebook.com/InsightEditions

🐦 Follow us on Twitter: @insighteditions

Library of Congress Cataloging-in-Publication Data available.

ISBN: 978-1-68383-485-4

Manufactured in China by Insight Editions

10 9 8 7 6 5 4 3 2 1